HOW TO DRAW CHARACTERS
FOR THE ARTISTICALLY CHALLENGED

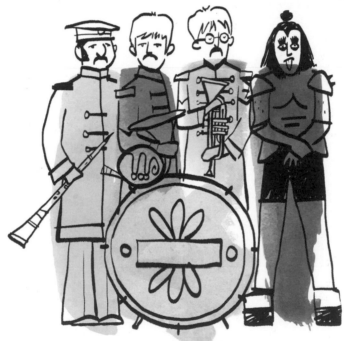

JOHN BIGWOOD

HARPER
DESIGN
An Imprint of HarperCollins Publishers

D0572549

ILLUSTRATED BY JOHN BIGWOOD
EDITED BY JOCELYN NORBURY AND PHILIPPA WINGATE

DESIGNED BY JOHN BIGWOOD
COVER DESIGN BY ZOE BRADLEY AND LYNNE YEAMANS

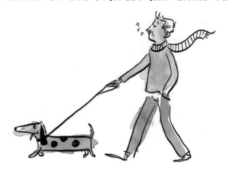

First published in Great Britain in 2018 by LOM ART, an imprint of Michael O'Mara Books Limited,
9 Lion Yard, Tremadoc Road, London SW4 7NQ www.mombooks.com

HOW TO DRAW CHARACTERS FOR THE ARTISTICALLY CHALLENGED

HarperCollins books may be purchased for educational, business, or sales promotional use.
For information please email the Special Markets Department at SPsales@harpercollins.com.

Published in 2018 by
Harper Design
An Imprint of HarperCollinsPublishers
195 Broadway
New York, NY 10007
Tel: (212) 207-7000
Fax: (855) 746-6023
harperdesign@harpercollins.com
www.hc.com

Distributed throughout North America by
HarperCollins Publishers
195 Broadway
New York, NY 10007

ISBN 978-0-06-269152-1
Library of Congress Control Number 2017958699

Printed in China

First Printing, 2018

INTRODUCTiON

Do you find people impossible to draw? Are you intimidated by facial expressions and complicated poses? Don't put down your pens just yet— a solution lies within these pages.

Forty-six watercolor splotches are waiting to be transformed into a cast of cool and quirky characters. All you have to do is use the illustrated examples as inspiration to add faces, poses, and accessories. Worry not about squiggly lines, weird features, smudges, or scribbles—every stroke of your pen adds personality and flair. These characters are yours to bring to life.

Add a pout to a pinup, adorn a rapper with his rightful bling, and give a boy band all the right moves, as you forget your fears and reveal your inner artist. What are you waiting for? Just pick up a pen and follow the prompts to create a host of characters that celebrate the perfectly imperfect in all of us!

DOG WALKER

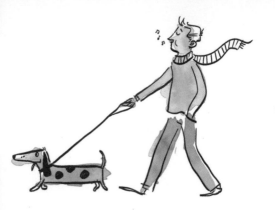

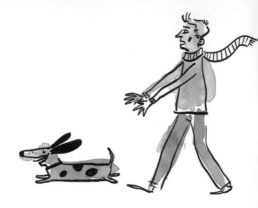

Careless whistle

Dog on the loose

Poop bag

Leash

Strolling along

Freedom!

Legs

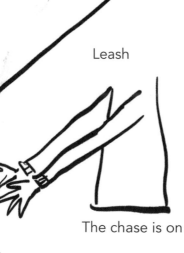
The chase is on

Windswept scarf

Sprinting dog

Strutting dog

Casual walk

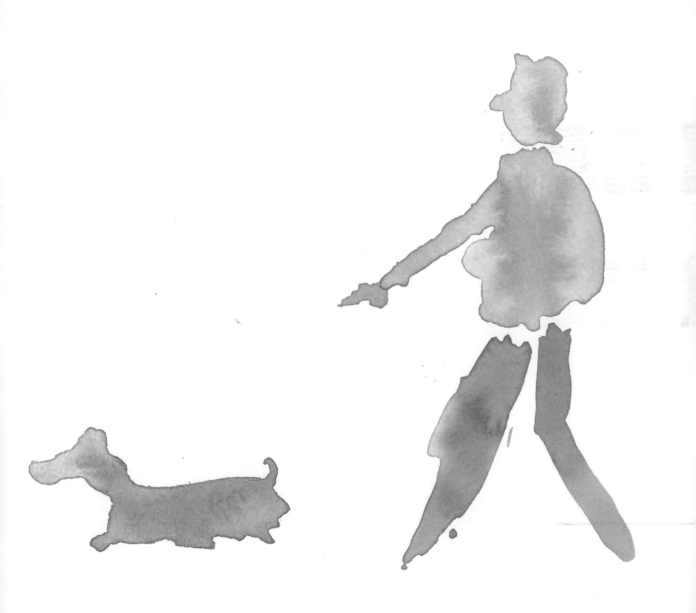

ARTIST

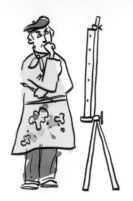

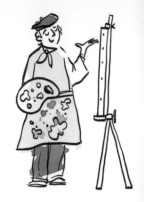

Art critic

Artistic genius

Con artist

Smock

Neckerchief

Beautiful mess

Paintbrush

Legs

Palette

Easel

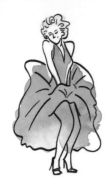

PiNUP

Some like it hot

Legs

Happy birthday, Mr. President

Face

Pout

Singing

Birthday arms

Body

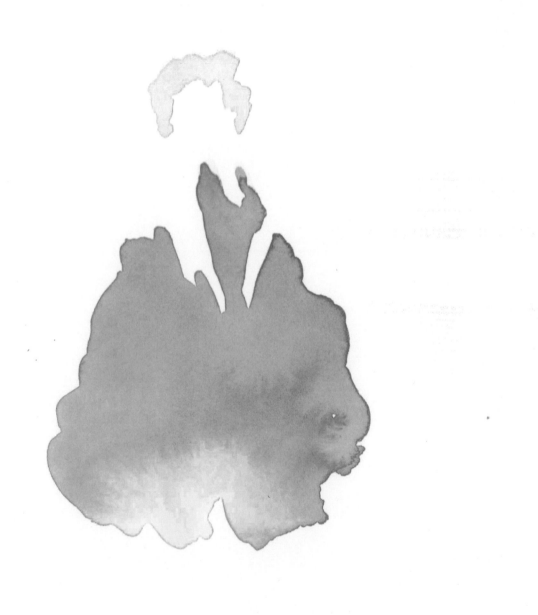

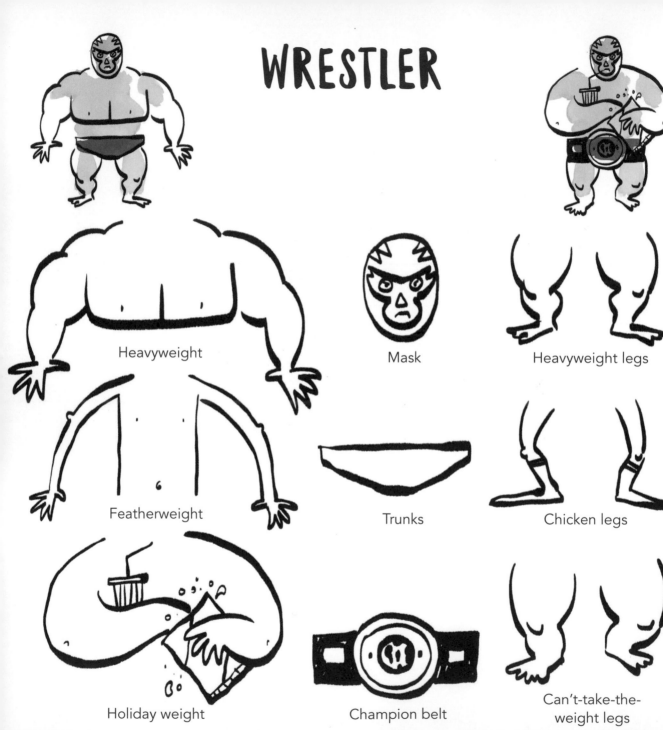

WRESTLER

Heavyweight

Mask

Heavyweight legs

Featherweight

Trunks

Chicken legs

Holiday weight

Champion belt

Can't-take-the-weight legs

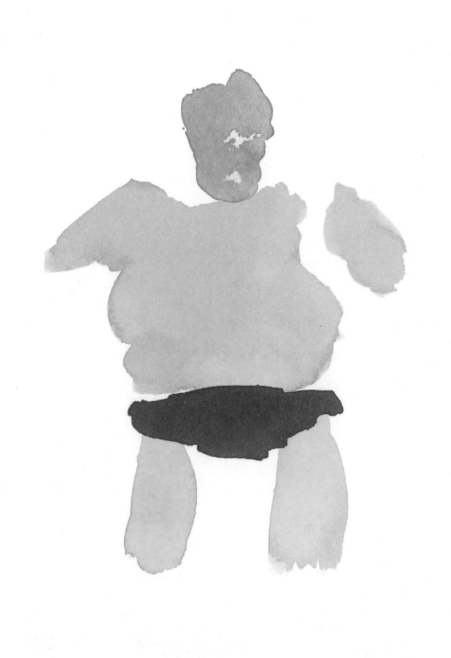

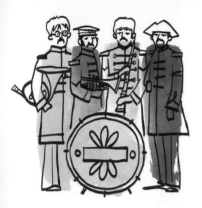

I'M WITH THE BAND

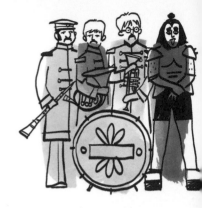

John

Ringo

Paul

George

Wrong band

French horn

Yellow suit

Pink suit

Blue suit

Red suit

Doesn't suit

Trumpet

Drum

Clarinet

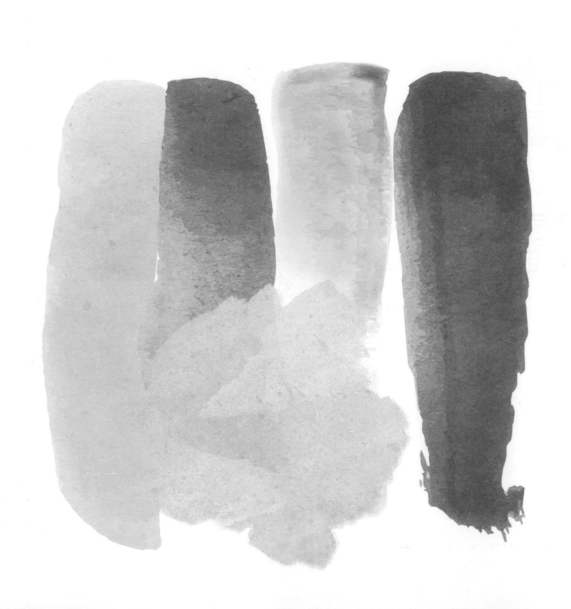

FISHERMAN

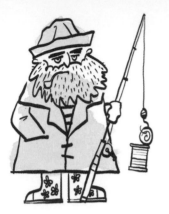

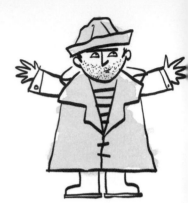

Gone fishing

Weather-beaten

Stowaway

"It was THIS big"

Waders

Designer waders

Waterproof

Reeling one in

Hearty pipe

Whoa! That's a big one!

Big disappointment

CLOWN

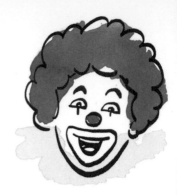

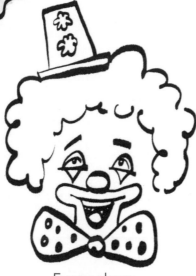

Funny clown

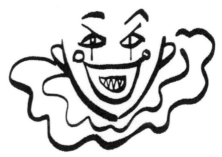

Scary clown

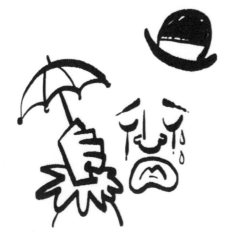

Tears of a clown

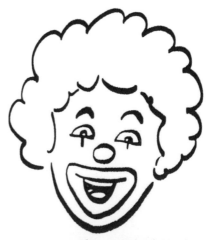

Do-you-want-fries-with-that clown

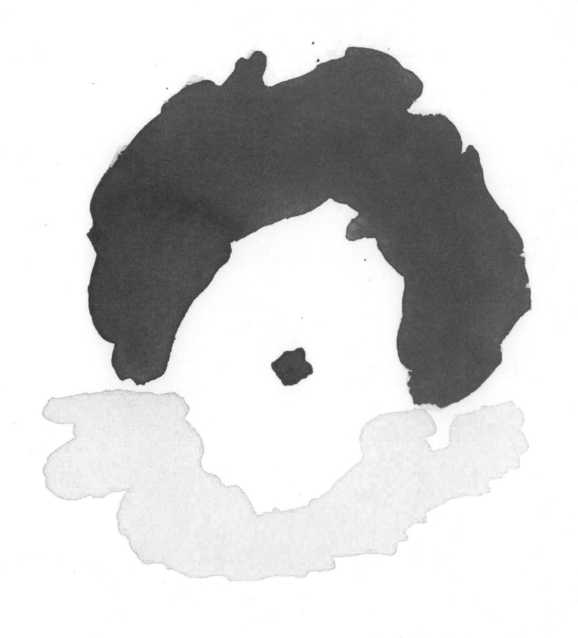

IN BUSINESS

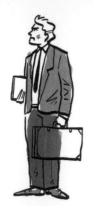

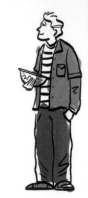

Market crash

Dressed to impress

Casual Friday

Business folder

Economic boom

Takeout salad

Credit crunch

Briefcase

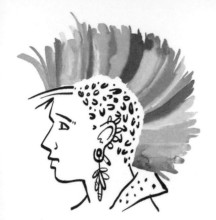

PUNK

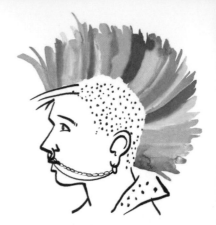

Rebellion

Anarchy

Minor revolution

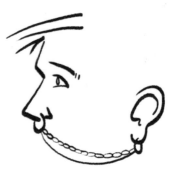

Serious hardware

Leopard

Let it grow

Profile

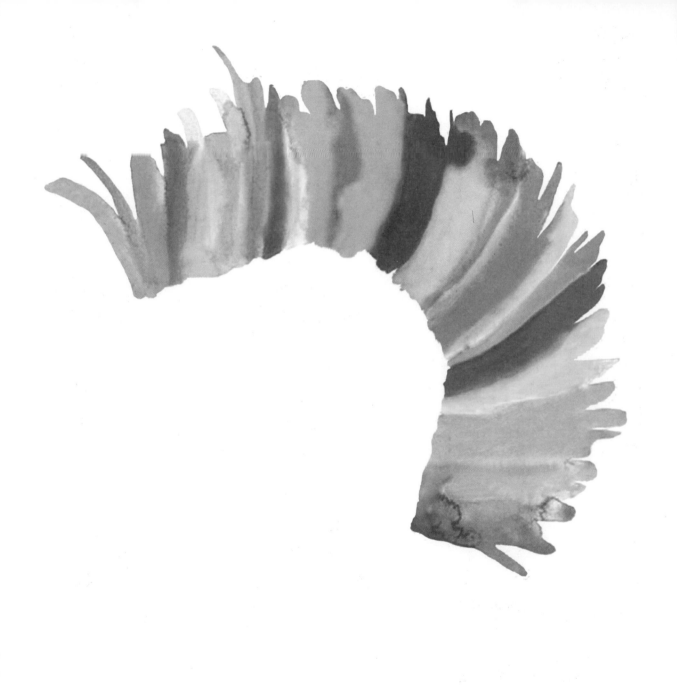

STUDENT

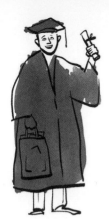

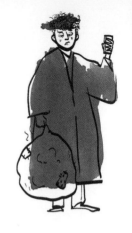

Good grades

Bottom of the class

Egghead

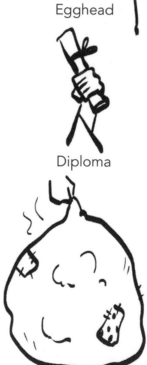

Diploma

Graduation gown / Bathrobe

Homeward bound

Bed head

#graduation

Library fine

SUPERHERO

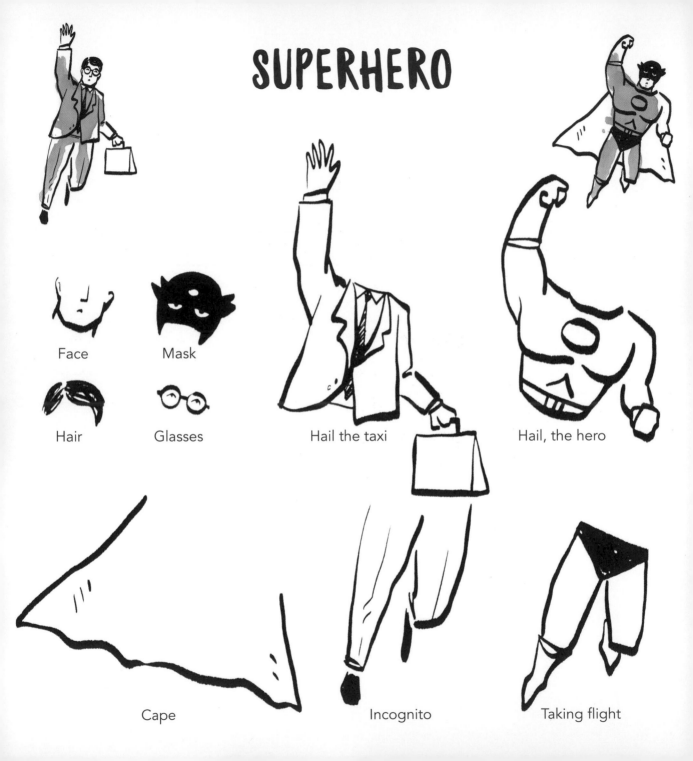

Face

Mask

Hair

Glasses

Hail the taxi

Hail, the hero

Cape

Incognito

Taking flight

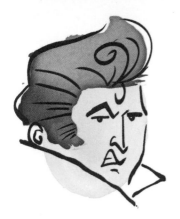

ELVIS
IMPERSONATOR

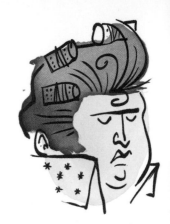

All shook up

Peanut butter and banana face

Day-off Elvis

Stage Elvis

Dressing-room Elvis

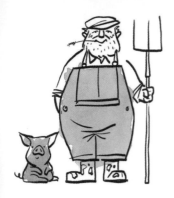 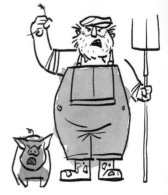

FARMER

At one with the land

Get off my land!

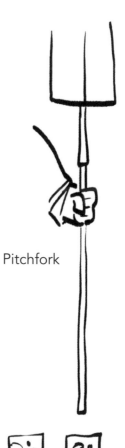

Pitchfork

Pet pig

Overalls

Attack pig

Work boots

BEAUTY-SCHOOL DROPOUT

Shampoo and set

What's love got to do with it?

Emergency wig

Eyes

Nose

Face and neck

Coy smile

Beauty mark

DETECTIVE

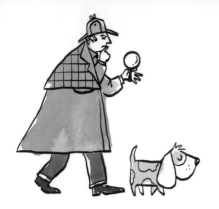
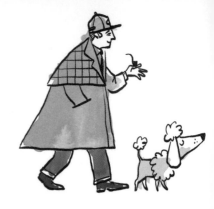

Thoughtful

Suspicious

Confounded

Private eye

Off duty

Legs

Armed and dangerous

Coat

Bloodhound

Bling hound

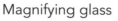
Magnifying glass

Pipe

RAPPER

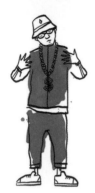

No downloads

Top of the charts

Billboard hit

Serious beats

Tracksuit bottoms

Fresh threads

Check me out

Straight outta the '80s

Pristine snapback

Headphones

Chillin'

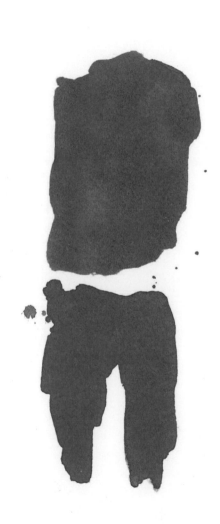

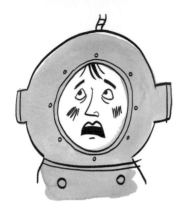

DEEP-SEA DIVER

Ah, pretty fishes

Pretty fishy

Shark attack!

Feeling seasick

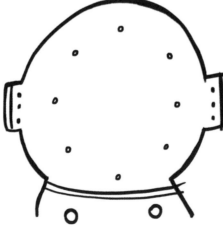

Diving helmet

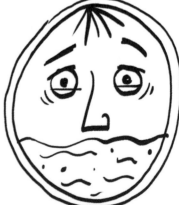

Definitely seasick

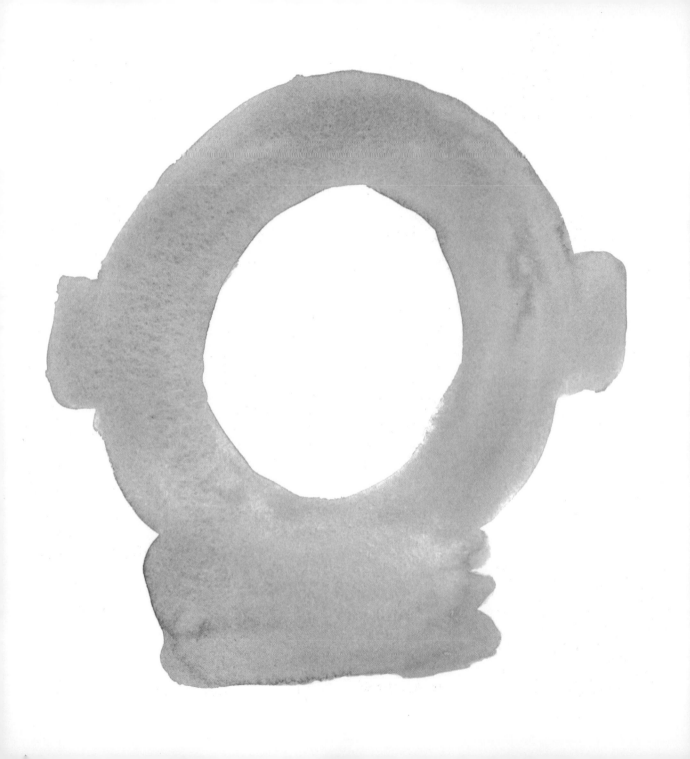

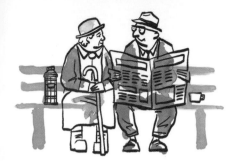

COUPLES

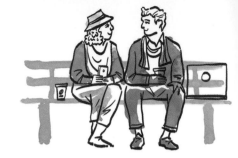

Old flames

Young love

Walking stick

Newspaper

News feed

Mobile phone

Hot chocolate

Flat white

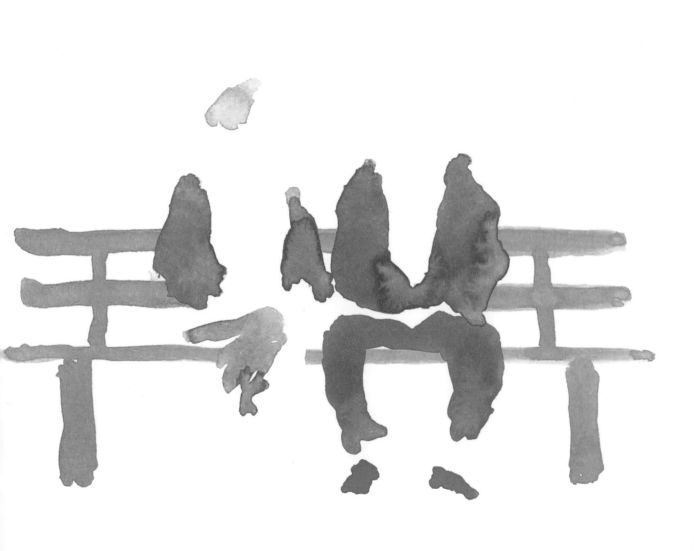

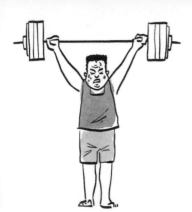

EXERCISE ENTHUSIAST

Deep burn

Burning calories

Burning the candle at both ends

Muscle tank

Shorts

Guns

Legs of steel

Weights

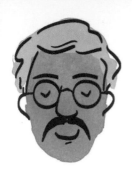

MASTER OF DISGUISE

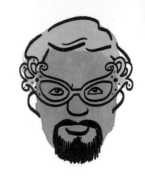

Grandpa

Geek

Fancy

Blind as a bat

Nose

Hair

Tom Selleck 'stache

Mouth

Goatee

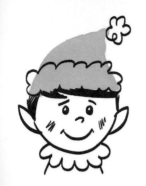

ELF

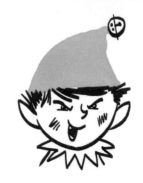

Santa's elf

Sulky elf

Satan's elf

Pom-pom

Bell

Fur trim

Ears

AUDREY

Gloved hand

Bow lips

Breakfast at Tiffany's

Breakfast in bed

Bed head

Face and neck

Cat eyes

Raccoon eyes

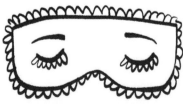

Do not disturb

BARISTA

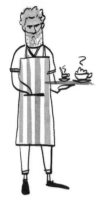

Single espresso

Double hazelnut latte

Soy latte, extra hot, whipped cream

Skinny jeans

Skinny legs

Apron

Frothy coffee

Espresso

To go

Avocado toast

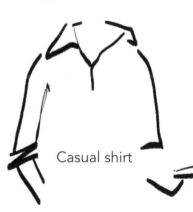

Casual shirt

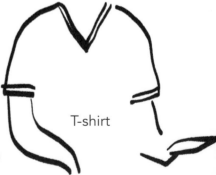

T-shirt

DANCER

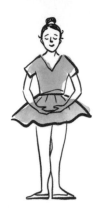

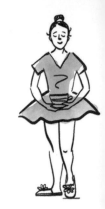

Prima ballerina assoluta

Tutu

Poised

Caffeine hit

First position

Second position

Third position

Off duty

SELFiE

Photo ready

Photo NOT ready

Filtered face

Photobomb

The wrong cheeks

BOY BAND

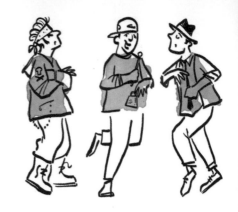

The joker

The one with
all the moves

The
talented one

The dreamy one

The bad boy

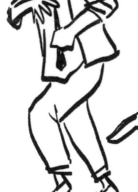

Guitar

Mic

Triangle

Cowbell

FLAMENCO DANCER

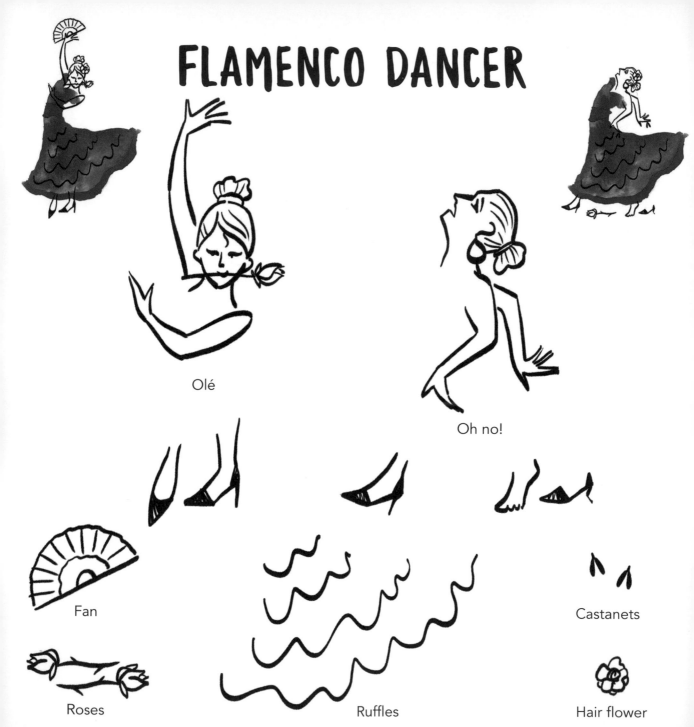

Olé

Oh no!

Fan

Castanets

Roses

Ruffles

Hair flower

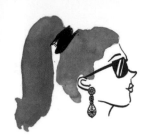 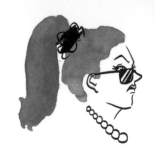

PARK AVENUE PRINCESS

Uptown

Downtown

Get outta town

Scrunchie

Pearls

Family jewels

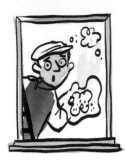

WINDOW CLEANER

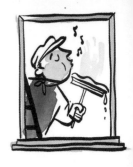

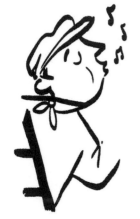

Whistle while you work

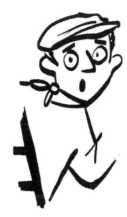

Uh-oh

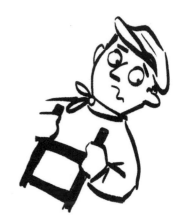

Timber!

Soap suds

Squeegee

Window frame

Bird poop

Soapy cloth

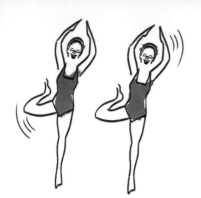

SYNCHRONIZED SWIMMERS

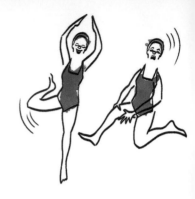

High score

No points

Swimming cap

Nose clip

Swimsuit

Water ripples

Perfect points

Cramp!

NUTTY PROFESSOR

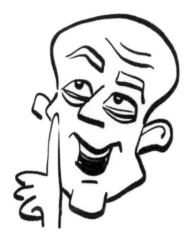

Back to the future

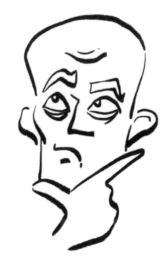

Back to the drawing board

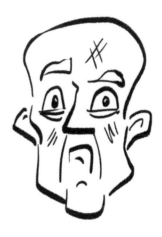

Back to bed

Wild hair

Anyone seen my goggles?

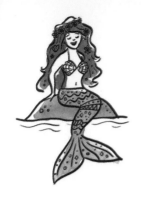

MERMAID

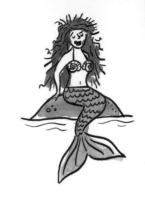

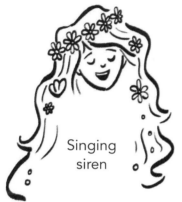

Singing siren

Washed ashore

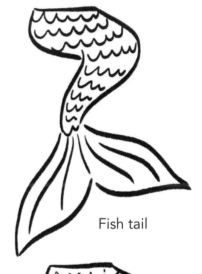

Fish tail

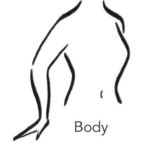

Body

Seashell bikini

Snail-shell bikini

Sea rock

Fairy tail

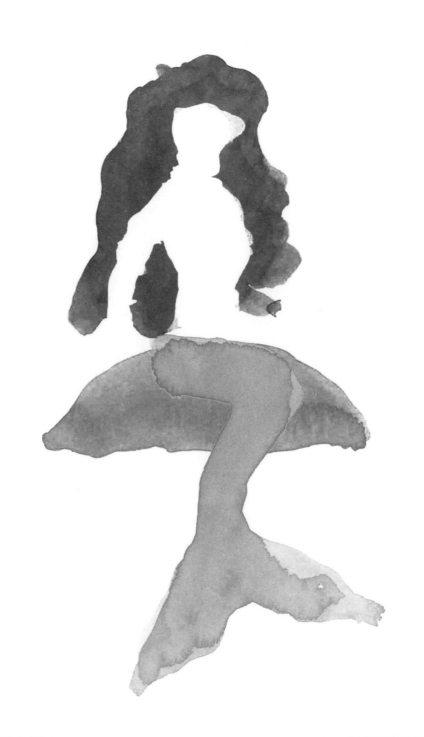

HiPSTER

Theodore Roosevelt 'stache

Hercule Poirot 'stache

Salvador Dalí 'stache

Fu Manchu 'stache

Ears

Eyes

Hair

Nose

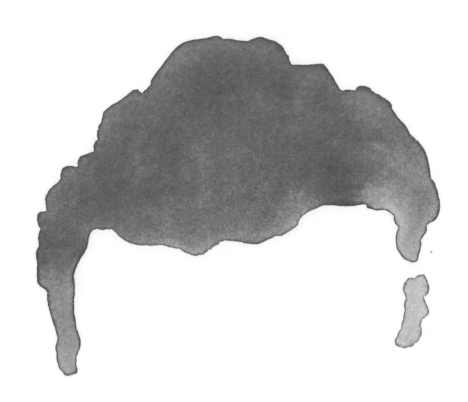

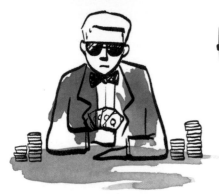

HIGH ROLLER

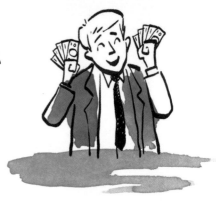

Fan of money

Fan of cards

Gambling chips

Tie

Sunglasses

Casino Royale

Poker face

Losing hand

Ka-ching!

BEARDY

Trendsetter

Carefully coiffed

Specs appeal

Incognito

Carefully concealed bald spot

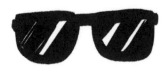

Going underground

CHEF

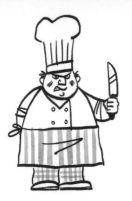

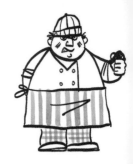

Head chef

Sous chef

Little chef

Dishwasher

Apron

Chef's coat

Legs

Boiling

Slice and dice

Scrubber

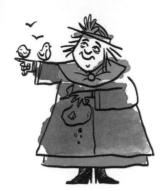

BIRD LADY

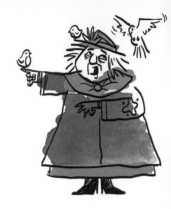

Feed the birds

Argh, incoming!

Pretty birdies

Dinner is served

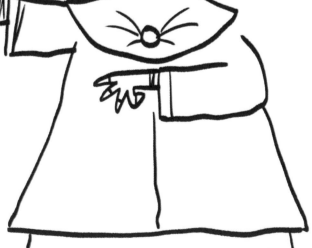

Attack pigeon

Boots

Coat

SPLAT!

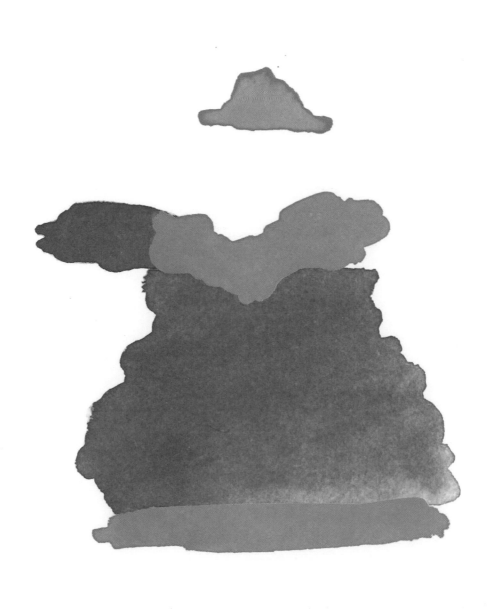

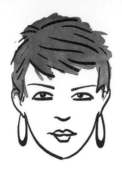

'80s ROCK GODDESS

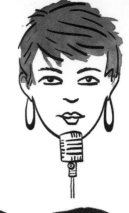

Joan Jett

Pat Benatar

Debbie Harry

Glam crop

Microphone

Face

Mouth

Hoop earrings

ORCHESTRA CONDUCTOR

Lost in music

Lost the mojo

Lost the baton

Sound of music

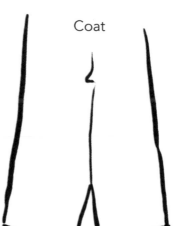

Coat

Legs

Hair

Music stand

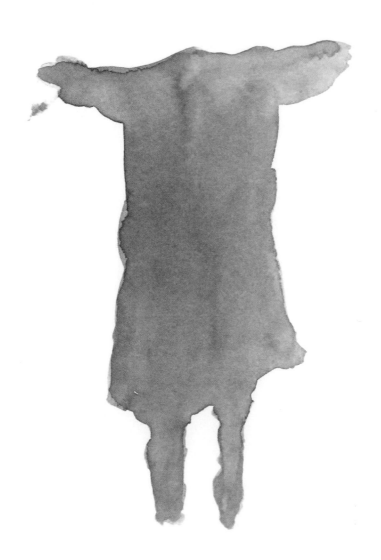

PROM QUEEN

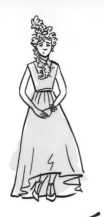

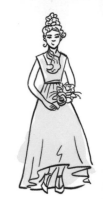

Dream dress

Princess hair

Overdone it

Undatable

The friend zone

Perfect date

Arms

Blisters

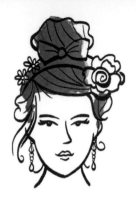

BRIDE AND GROOM

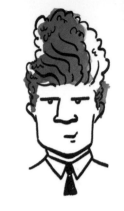

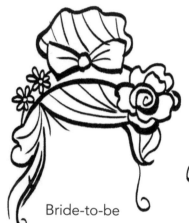

Bride-to-be

Bride of Frankenstein

Well groom-ed

Not groom-ed

Something old

Something new

Something borrowed

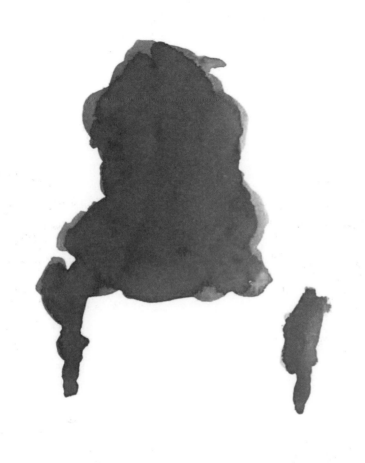

AGING FACE

Baby face

Teen angst

Midlife crisis

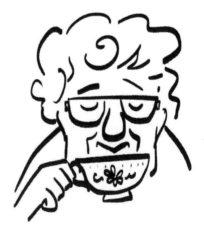

The golden years

LION TAMER

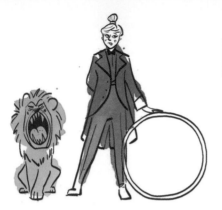
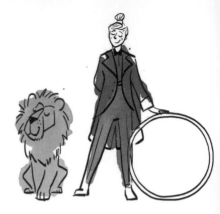

Will not be tamed

Will jump for treats

Failed it

Nailed it

Hoop

King of the jungle

Queen of the ring

NEWS FLASH

Bad news

Good news

News to me

Power suit

Script

Meaningless graphic

GLAMOUR GiRL

Wide-eyed and innocent

Hot and sultry

Too much eyelash glue

Face

Va-va-voom hair

Nose

Lips

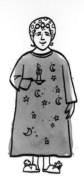

BEAUTY SLEEP

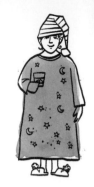

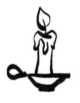

Night-light

Nighttime reading

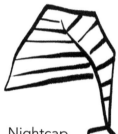

Nightcap

Nightcap

Nightgown

Starry, starry night

Beauty sleep

Slippers

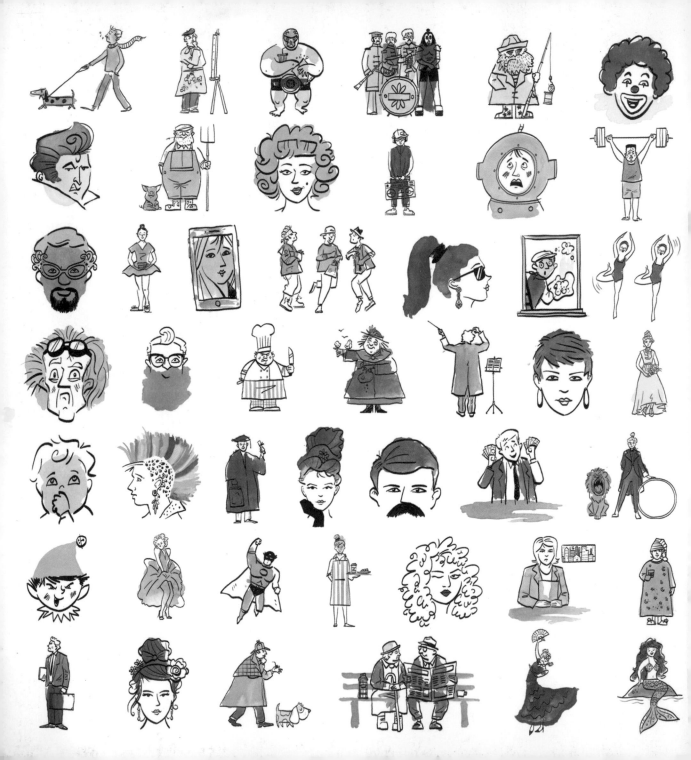